To think that at the beginning of the celebration of our 10th anniversary year we are having the privilege of exhibiting the wonderful paintings by George W. Bellows gives me a great deal of pleasure, satisfaction and pride. These portraits, views of Monhegan Island, Maine and Woodstock, New York represent some of the very best paintings created by the artist.

My thanks to the museums that have loaned their Bellows paintings. My recognition and thanks to our supporters that have made it possible to organize and bring the exhibit to the Central Florida community. My appreciation to Marjorie B. Searl and Glenn Peck for their insightful essays on the artist and his work. My gratitude to our director, Frank Holt for curating and facilitating the exhibit. And, to the memory of my beloved Marilyn, a true supporter of the arts and of all that makes life worth living.

Michael Aloysius Mennello
Founder
The Mennello Museum of American Art

The Paintings of
George Bellows

November 2, 2007 – February 24, 2008

THE MENNELLO MUSEUM OF AMERICAN ART

900 E. Princeton Street • Orlando, Florida 32803
407.246.4278 • www.mennellomuseum.org

The Mennello Museum of American Art is owned and operated by the City of Orlando.

Cover: George Bellows, (American, 1882-1925), *My House, Woodstock*, 1924, oil on panel, 17.75 × 22 inches.
Collection of Michael A. Mennello. Photo courtesy of Carol Irish Fine Art.

ISBN 0-9668799-1-0

Lenders to the Exhibition

Bank of America Corporate Art Collection, Charlotte, North Carolina

John and Dolores Beck, Winter Park, Florida

Berry-Hill Galleries, Inc., New York, New York

Butler Institute of American Art, Youngstown, Ohio

Columbus Museum of Art, Columbus, Ohio

Farnsworth Museum of Art, Rockland, Maine

Samuel P. Harn Museum of Art, University of Florida, Gainesville, Florida

Michael A. Mennello, Winter Park, Florida

The Metropolitan Museum of Art, New York, New York

Mint Museum of Art, Charlotte, North Carolina

Telfair Museum of Art, Savannah, Georgia

Sponsors

Bright House Networks

Lockheed Martin

Michael Aloysius Mennello

KPMG LLP

The Friends of The Mennello Museum

Orange County Government, Florida, Arts & Cultural Affairs

The catalog and exhibition are dedicated to The Honorable Marilyn Logsdon Mennello.
As you all know, Marilyn was a driving force behind the creation of the museum.
Her spirit and vision will help to guide us as we grow and move into the future.

My sincere appreciation to Michael Mennello who has been so enthusiastically supportive of this exhibit that at times I became really concerned that it would not meet his demanding expectations. His knowledge of American Art and of the paintings created by George W. Bellows is extraordinary. We have had many conversations, pored over catalogs and books, and talked about the artist and the exhibit for hours. He is truly an educated collector and it has been and will continue to be a pleasure to work with him.

Frank Holt
Executive Director
The Mennello Museum of American Art

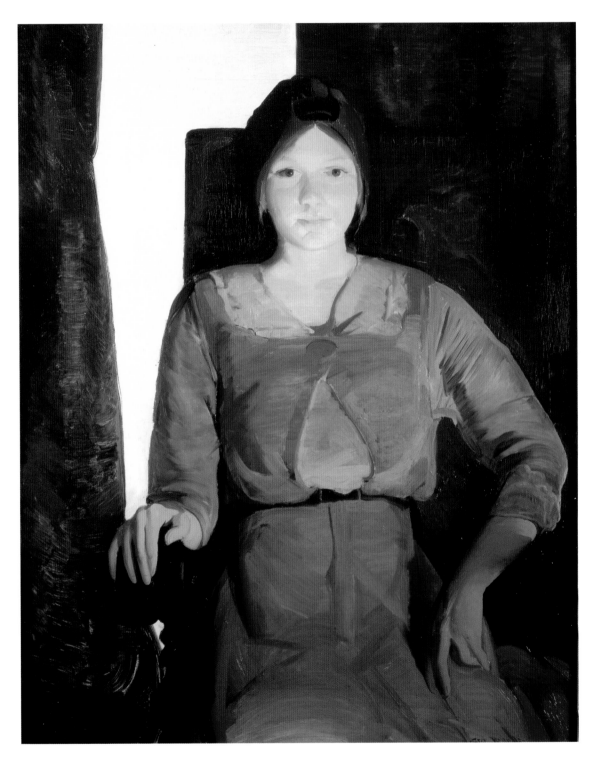

Geraldine Lee #2, 1914
Oil on panel
38 × 30 inches
Collection of The Butler Institute of
American Art, Youngstown, Ohio.
Museum Purchase 1941

From the Director

FRANK HOLT

One of the most rewarding experiences for the curator of an exhibition is to be there when the crates are opened, the paintings are unwrapped, and you confirm that the art works together as the cohesive exhibit you have envisioned. You may have seen the work before and had the gut feeling that the works would make a wonderful statement shown together. But until you have the paintings hung together in the building there is always the chance that something just might not work. That is not the case in this George W. Bellows exhibit. They are just what I had hoped they would be—perfect for the scope and size of the show.

The work is divided into three groups including scenes of the Maine coast, intimate portraits of his family and friends, and those almost perfect images of Woodstock, New York. There is an energy, force, and expression that can be traced from some of the earliest works produced in 1911 through the final images painted during the late fall of 1924.

Monhegan, an island ten miles off the Maine coast, was an early subject for Bellows. He and his family vacationed there and as a result he became intimate with the climate and changing weather patterns. The two Maine coast scenes *Island in the Sea* and *Gorge and River* were painted in 1911 and were based on views in and around the island. Both share an abstract depiction of the coast. There is an almost architectural quality to the cliffs. The boulders and rocks take

on monumental proportions. In Bellows's coastal scenes the land has a massive quality that is conveyed through shape, color, and composition. The land has to be strong to withstand the constant pounding of the waves.

In *Gorge and River* the water rushes through the break in the rocks in its journey to the sea. There is a sense of urgency and energy conveyed through the bold brushstrokes even though the color palette is muted. You almost have the feeling that Bellows has attacked the canvas with the paint. There are powerful, quick strokes of paint, very little mixing of color, and if you look closely, in the bottom left-hand corner, a truly brilliant shade of blue.

Island in the Sea is probably Manana Island, just off the coast of Monhegan. The painting can be somewhat deceptive, however, it is not simple. There is a sense of isolation, mystery, and melancholy about it. What makes the painting truly outstanding is the pale silver light from the unseen moon that dances across the water and land.

Light also shimmers across the surface of *Geraldine Lee #2*, painted in 1914. The sitter looks out from the canvas. Her face hints at a coming self awareness. She is moving from youth to adulthood—the pursuits of childhood have passed but the future is still uncertain. Bellows uses the paint to create texture in some areas and in others, he appears to place paint on the canvas and then remove it to create contrasting smooth areas.

Six years later he painted the 2nd portrait of his half-sister Laura. She had been ill for several years and the mood of the painting is very reflective. She quietly looks out from the canvas, her hands held in her lap. The color again is muted, the background indistinct.

The paintings created between 1920 and 1924 of the Woodstock, New York community are truly lyrical. Bellows has surrounded himself with family and friends. He has built a home *My House, Woodstock*, 1924. He is happy and productive. The mood is pastoral; the subjects familiar. The colors are a riot of green, red, yellow, and orange, and with those amazing blue skies.

It is my hope that you look, enjoy, learn and take away an appreciation for the paintings by one of America's greatest 20th century artists.

—Frank Holt
Exhibition Curator/Executive Director

Bellows and the Creative Concept

GLENN PECK

An old friend of mine has bought hundreds of paintings. You might say that he has an obsession. He is way past hanging pictures stacked three and sometimes four in a row on his walls. He ran out of exhibition space years ago and has taken to standing them still wrapped up along the baseboards. I have asked him why does he purchase so many paintings, and his response is that he finds in every work of art some part that is successful, that elicits a spark of excitement. This thrill might come from a well drawn figure, the harmony of the palette, or something as simple as the way one paint stroke is brushed along the next. In short his measure of success is finding and understanding some singular achievement in the work at hand. Most of us are more demanding in the art that we collect or even the works we view at museums. We want a painting to stimulate the mind on as many levels as possible and all at the same time. Great color, rich texture, a sense of the physical environment and some pervasive cognitive purpose are the hallmarks of greatness in art. Today we recognize George Bellows as a great American painter. His paintings contain all the important characteristics of genius. During his seventeen year career as an artist he completed about five hundred oil paintings and of this group over two hundred have entered into museums collections. We take for granted his significance and accept the common consensus that his works are important. What is often overlooked, however, is that his path to celebrity was

not an easy one. At the time of his death at the age of 42 in 1925, over ninety percent of his paintings remained unsold. His best known work, **A Stag at Sharkey's** (Cleveland Museum of Art) was finally bought by the museum in 1921, a dozen years after it was painted for a respectable, but hardly princely sum of $1,200.00. Now this painting can easily be valued at more than fifty million dollars and is considered a national treasure. Hindsight is a wonderful thing. Everything appears to make sense in a linear fashion when one success follows another, but the truth is that creative excellence is an elusive goal, and one, that Bellows, as a gifted painter, knew could vanish before an artist realized that it was even attained. His story is a compelling tale, and I feel fortunate that I am able to tell it after studying him for twenty-five years.

Before Bellows could paint he had to learn how to draw. During his years as an undergraduate at Ohio State his artistry was limited to illustrations for **The Makio**, the school yearbook, and pen and ink sketches that were slavish renditions of "Gibson girls." Charles Dana Gibson was a popular magazine illustrator of that time, and Bellows was no different than his peers in basing his work on these pretty belle époque models.

Bellows needed to get to New York City in order to begin his education. So, the would-be artist quit college as a junior and came east. He found a room at the YMCA and began a life-long immersion into the complex world of the

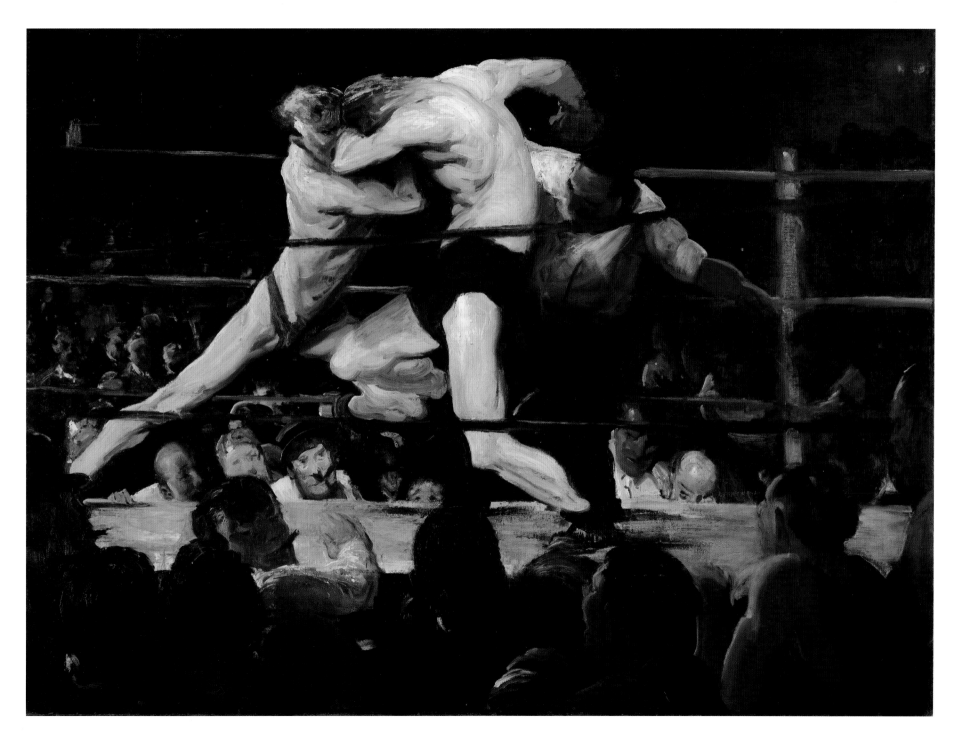

13

Portrait of My Father, 1906
Oil on canvas
28.375 × 22 inches
Columbus Museum of Art, Ohio
Gift of Howard B. Monett 1952.048

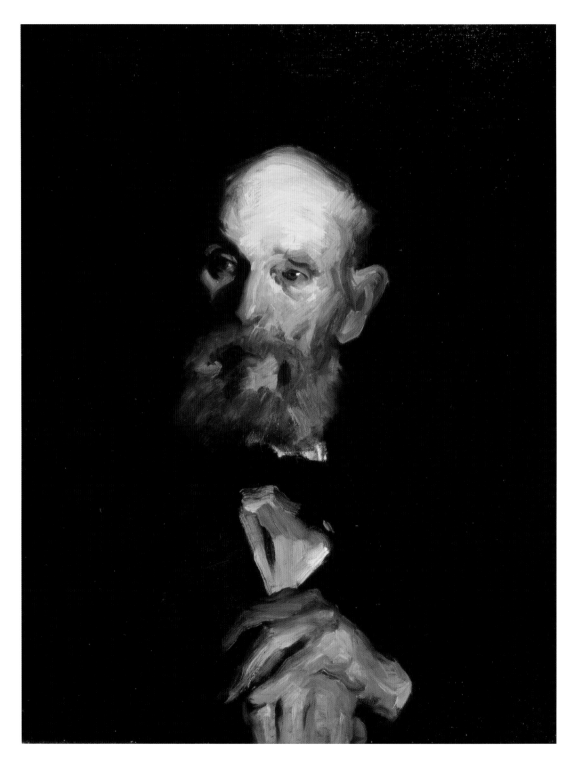

city. Much is made about his early association with Robert Henri and his classes with him, but in reality Bellows hardly painted at all during his first two years in New York. He lacked the skills of a painter and could not even begin to create compositions on canvas. As an alternative, he spent his first days absorbing the rich visual imagery of the parks, outdoor markets and the numerous tenement neighborhoods that made up Manhattan. Within months he had stored up a lifetime's worth of snapshots in his head and began to transcribe them into well-finished drawings that demonstrated both his keen observation skills and his immediate mastery of the principles of design and atmospheric effects. His quick competency as a draughtsman was remarkable, but what distinguished these first days was how he could sort the scenery into such fascinating pictorial gems. Even without seeing the works, one gets a sense of his vision by knowing only their titles. They included, among others, *Struggle with a Drunk, Watermelon Man, A Street Marathon, Kill the Umpire, Ma Thomas' Boarding House, San Juan Hill* and *Squalor*. The last work has an

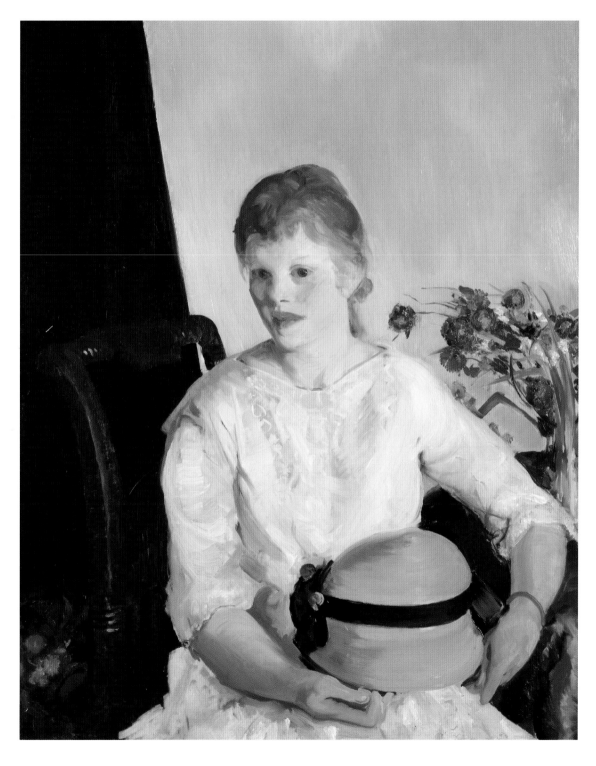

annotation in his record book that further describes the place portrayed. He writes: "A walk through crowded tenement streets, immense crowds of streaming people, covering all spaces, nude babies on sidewalk." His vocabulary is quite expansive in meaning. He could have said, "people hanging out of their windows above a crowded street under the elevated subway." Instead by choosing "covering all spaces", we get a glimpse into his mind and how he perceives what is there. His genius is his directness and his being able to impart his thinking to the viewer without loss of purpose. The phrase, "nude babies on sidewalk", brings forth all sorts of emotions to a reader: vulnerability, concern and questioning. Bellows makes us experience all of these feelings in his art, as well, and that is a big part of his greatness.

Fortunately, accompanying this exhibition is a showing of the Bellows' drawing collection from the Boston Public Library and within this group is a 1907 drawing entitled, *Dogs, Early Morning*. Bellows

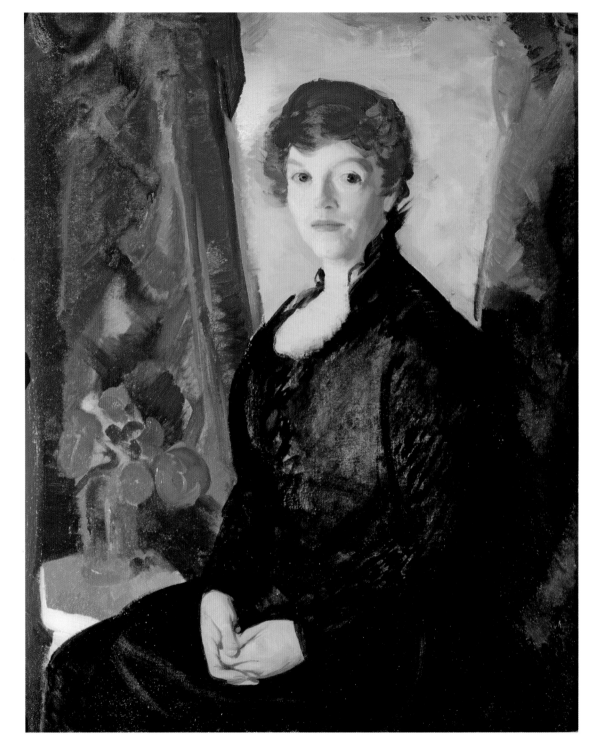

describes this work in his record book: "Dogs nosing in rubbish in a deserted street." His choice of subject matter is intriguing in its originality. Again he demonstrates his power as an artist. He put a lot of care in this drawing literally filling the page to the edges with dense crayon. By selecting what would at first seem to be an unsuitable subject, he is making the viewers question his judgment and also their judgment about what art should be. He instills curiosity, and this drawing with a few others of the slums of New York led in large part to the whole concept of the Ashcan School. In sum, the artist at such a young age (twenty-four) could help shape thought of a whole generation of painters and subsequent historians, and this is a remarkable feat.

As a young painter under the guidance of Robert Henri, Bellows began by painting models, classmates and family members. His first dozen efforts were for the most part earnest, yet conventional, evidencing little more than factual reporting. They were painted in

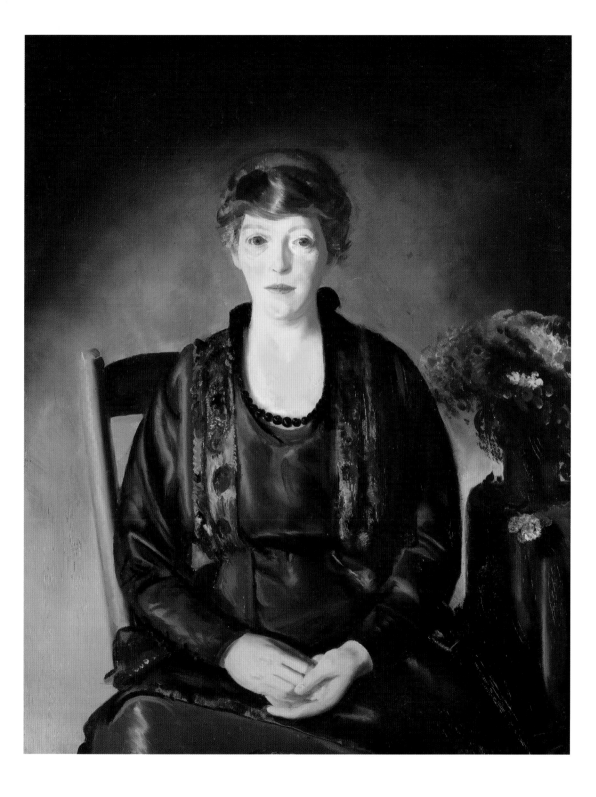

Laura, 1922
Oil on panel
40 × 32 inches
Collection of Michael A. Mennello

the limited hues of black, brown and white prevalent in an introductory painting class. The first likeness to transcend these limitations was his **Portrait of his Father** (Columbus Museum of Art, Ohio) that he completed over the Christmas holiday in 1906. Here he sought out the essence of the father he dearly loved and composed a tender rendition of this frail man, then seventy-seven years of age. The elder George was an architect, and in this likeness his son emphasized the importance of his hands that were instrumental in building things. Now weathered and beat, they are still stronger than the face. The beard hides only partially the sunkenness of the cheeks and the eye sockets are withdrawn. Dignity is maintained through a steady gaze and proper bowtie. Again, though, our attention returns to the hands which define him and that personality Bellows has brought to life.

With each passing year the artist introduced more colors onto his palette and applied them with greater ease. The resultant likenesses became more psycholog-

ically penetrating while the canvases themselves became brighter, clearer and more pleasing to the eye. Fellow artists and models continued to sit for Bellows, as well as half a dozen professors of note from his alma mater, but the most spectacular new works were of children. Clearly this was one area where the artists learned from his teacher, Henri. There is an immediacy in both artists' youths. They are animated and full of character. For Henri and Bellows the young people were almost always caught with an element of surprise in their faces, as if they did not know that they were sitting for a painting. Bellows' **Lillian** (Beck Collection, Winter Park, FL) from 1916 is an excellent example of this body of work. She sits twisting sideways in her chair while carefully folding her hands around her beautiful, ribboned chapeau. Her gaze is wide eyed and her mouth is slightly open, caught between an inhale and an exhale. She looks upon us and stays suspended in a moment of innocence.

Bellows never stopped painting his family. They were part of his autobiography in paint. Father, mother, wife Emma, daughters Anne and Jean, Aunt Fanny and his half-sister Laura were all portrayed more than once. Without question they remained his most intimate models. The extended family was always close at hand sharing vacations and holidays together. While the children revealed the joys of fatherhood, the renderings of the older generation displayed a deep understanding of the self knowledge that comes with

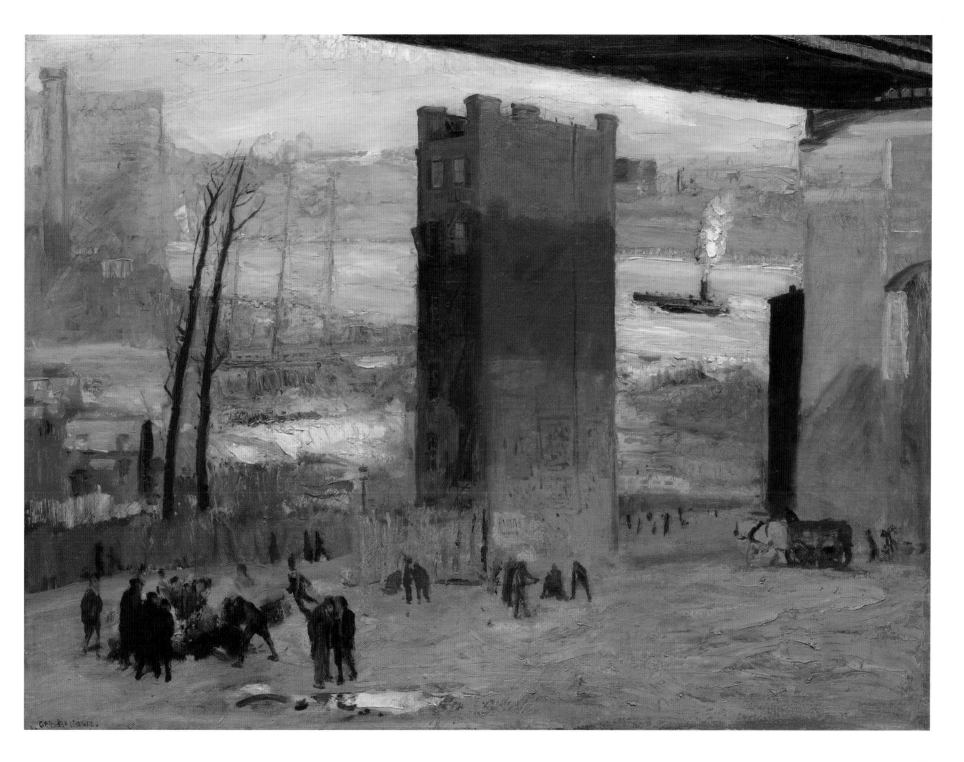

advanced years. Laura stands alone in middle age. She was eighteen years older than her half brother, married young, but was also a widow at forty-seven. Bellows painted her thrice. He was dissatisfied with the first effort in 1909 and destroyed it, but kept the other two, from 1915 and 1922 (Mennello Collection, Winter Park, FL), respectively. The earlier version, now owned by the Huntington Library and Art Gallery, San Marino, CA, shows Laura resplendent in a black dress with high collar. She embodies physical strength with her erect posture, squared shoulders and piercing eyes. When she sits again seven years later, Laura remains a strong presence, but the experiences of the intervening years have clearly impacted on her character. Her shoulders are a little more rounded and her gaze though steady is more introspective. The hands that had nestled together in the earlier portrait now barely interact. One gets a sense that life is slipping away and indeed Laura would pass away within two years. There is no denying, however, the power of this work. In it Bellows forces us to see with our eyes, yet feel with our hearts his overwhelming empathy for his only sibling.

Throughout Bellows' career, portraiture played a key part in his artistic production; more than one fourth of his paintings were portraits. His continued fascination with the individual served two purposes. Not only did it allow him to develop an emotional connection between paint and personality, it also

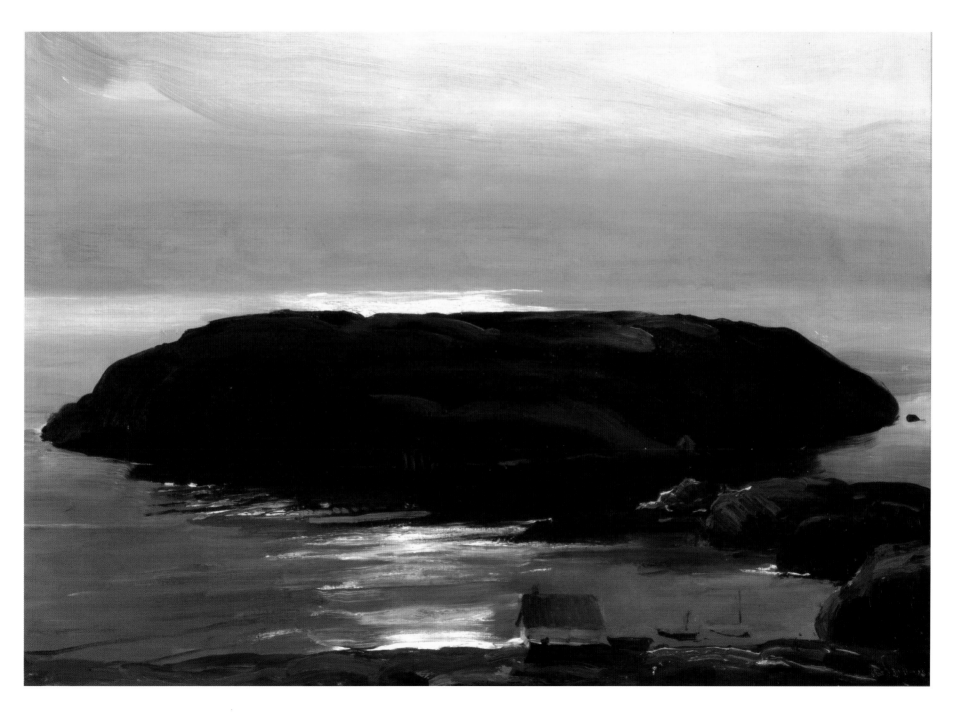

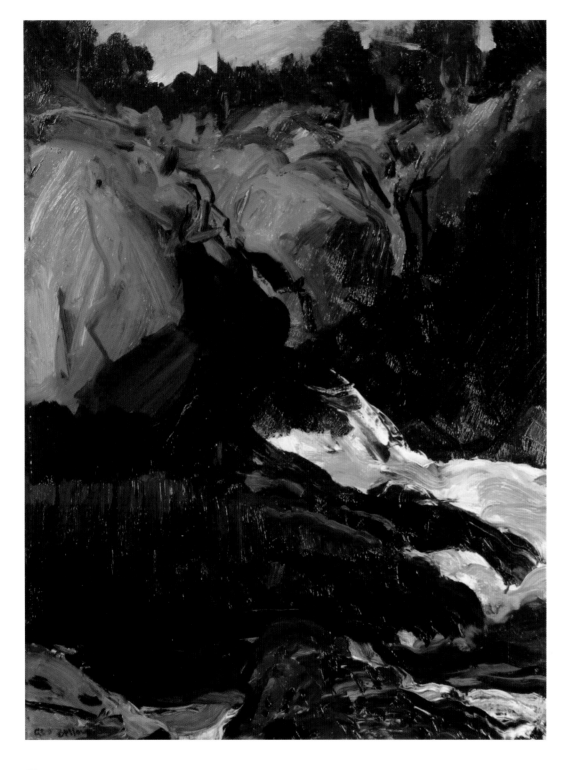

Gorge & Sea, 1911
Oil on canvas
34 × 26 inches
Mint Museum of Art
Charlotte, North Carolina
Gift of the Mint Museum Auxiliary. 1983.35

permitted him to refine his mastery of mixing pigments on a canvas. Bellows, however, never let portraiture trespass unto the abstract world. The likeness remained a fixed goal and therefore limited what the viewer was going to experience. Drawings were also restrictive in their expressive possibilities. Line and contour formed the figures in his compositions, and as such never blended into their surroundings. It was only when Bellows decided to merge his skills as a composer of complex drawings with his adept application of dollops of oil paints did he find his real liberation as an artist. Each pass of the brush on the canvas laid a thick line of impasto. This streak of pigment would start a whole creative process. One after another each new stroke defined a window, a cloud, a figure in the distance. Undoubtedly, this semi-abstraction made perfect sense to the artist. This evolution in his abilities occurred rapidly after 1907. Consequently, if you stand before one of his classic city scenes from 1909, such as **The Lone Tenement** (National Gallery of Art, Washington, D.C.), for example, and put your nose inches from the surface, all you see are

The Rich Water, 1913
Oil on panel
15 × 19.5 inches
Collection of John and Dolores Beck

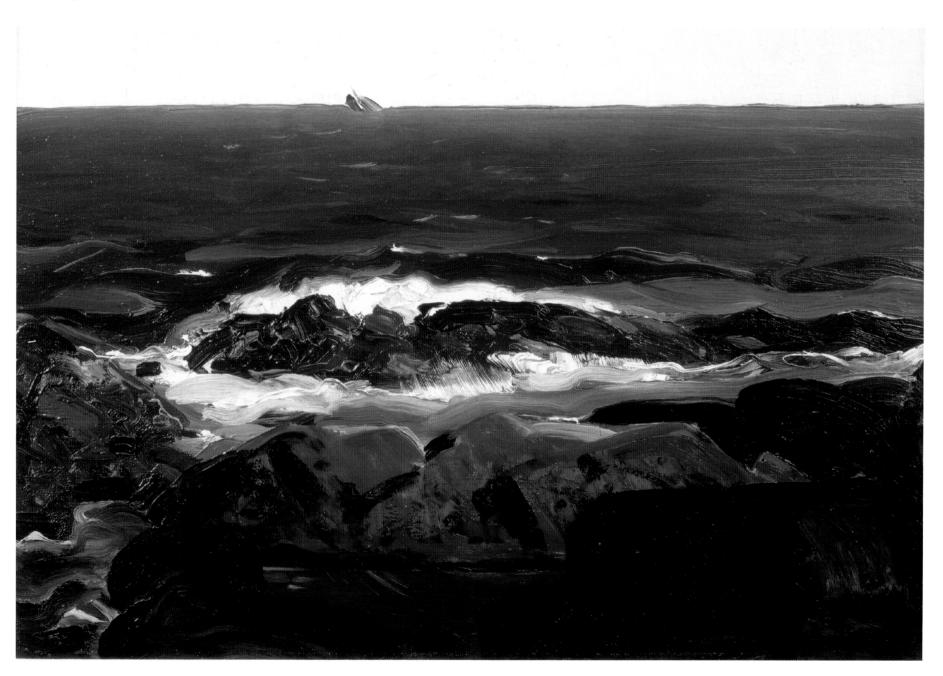

big globs of paint. When you move back six feet, everything takes shape. Buildings, people and trees all begin to distinguish themselves from the forest of brushstrokes. While we struggle with this transformation in our viewing, we also grasp that Bellows was fully conscious of this dynamic interchange between abstraction and representation in the work while he created it and that he is in complete command of our sensory perception. This remarkable talent has made him one of the biggest crowd pleasers in American art.

Between 1909 and 1912, Bellows found an ample supply of subjects to paint in and around the city. The East River and the Hudson, which circled the island, served as the stage for more than twenty elaborate vistas populated by tugboats, bridges and frolicking kids at water's edge. Another handful of paintings centered on the sports of boxing and polo, while yet a third cluster dealt with the constant congestion and construction going on in the metropolis. Bellows was always searching for a provocative scene that he could bring to life. It may seem obvious to us today, but this selection process was born out of a need to distinguish himself from his peers. The art world was extremely competitive, and he knew that to win critical praise and hopefully find clients he would have to paint with originality and also on a grand scale that would get noticed. While the critics took an immediate liking to his large, vibrant works, the buying public with the exception of some astute museum curators

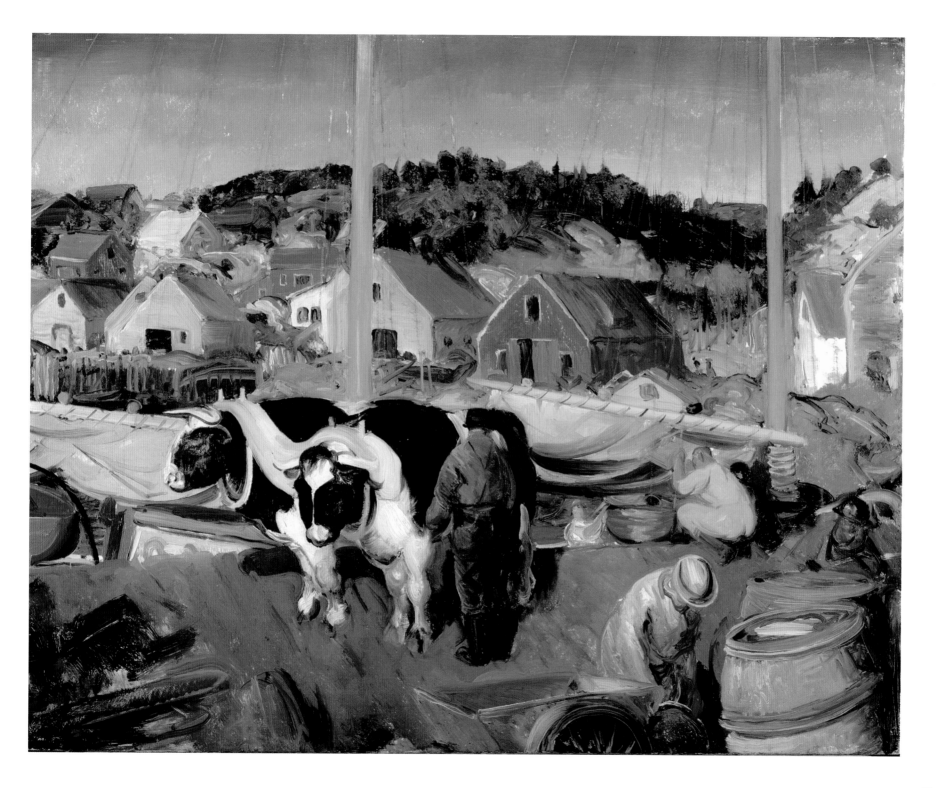

was slow to embrace him. It would take literally decades for most of the iconic scenes of New York City to find purchasers. Regrettably, many of these sales occurred in the 1940's and 1950's, long after his death. Bellows did not survive on the income generated from his art. Instead he subsisted on monies given to him by his father. These funds allowed him to marry, buy a townhouse, start a family and escape the bohemian existence of an impoverished painter. The lack of sales did not deter Bellows from being an artist; however, it did alter his daily routine. Beginning in 1912, he readily accepted commissions from magazines, such as **Everybody's Magazine** and **Harper's Weekly**, to illustrate stories. These assignments provided a source of income, but they also kept him from his easel. Over the following years, his portrayals of city life appeared with less and less frequency, and the metropolis became more a place to live and less a place to paint. Fortunately for us, Bellows never gave up his brush completely, and would find new inspiration away from New York.

Every July from 1911 until 1916, Bellows escaped the sweltering heat of the city and headed for cooler places. Maine was his favorite destination, and he would spend up to three months there on extended vacations, visiting either coastal communities such as Camden or Ogunquit, or venturing out to the islands of Monhegan and Matinicus. While these excursions could be considered times of leisure, the artist spent hours every day painting, and dur-

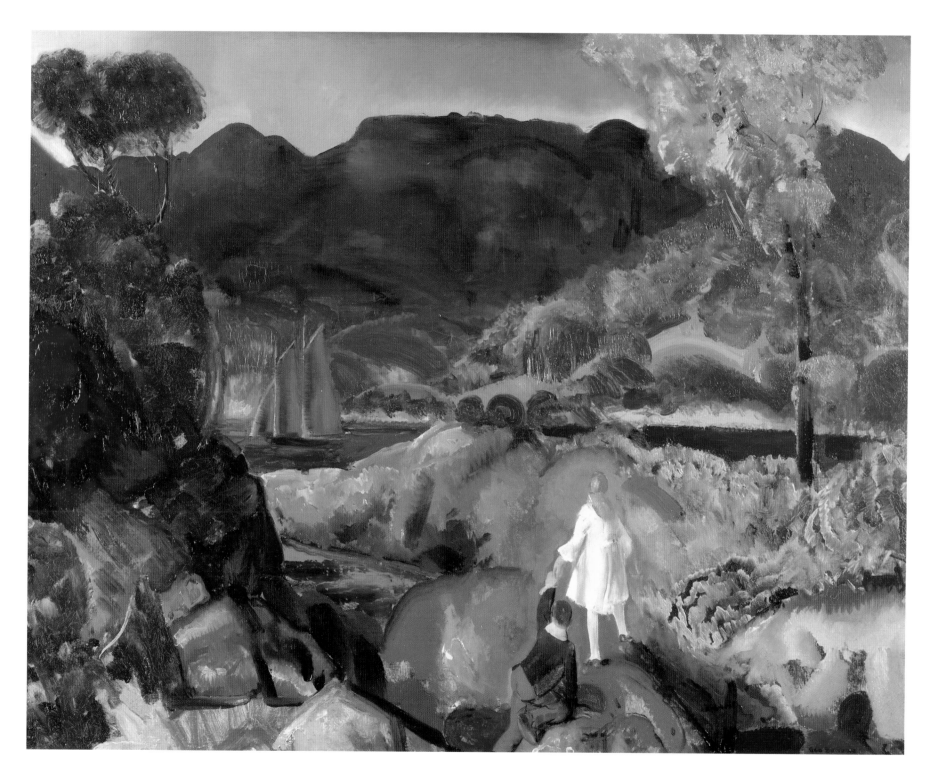

ing one particularly active summer on Monhegan in 1913, for instance, he managed to complete over one hundred seascapes, or more than one for each day of his stay! Monhegan was an idyllic place to depict. It had the massive cliffs of Blackhead and Whitehead towering above the sea on its eastern edge, a charming fishing harbor on its western side and several hills in the center that allowed for sweeping vistas of the ocean and mainland ten miles distant. Bellows explored every nook and cranny of this place: painting from the top of the island the neighboring Mananna in **An Island in the Sea** (Columbus Museum of Art, OH); the eastern headlands in **Over to Blackhead** (Telfair Museum of Art, Savannah, GA); and the water's edge in **Gorge and Sea** (Mint Museum of Art, Charlotte, NC) and **The Rich Water** (Beck Collection, Winter Park, FL). Bellows' "vacation paintings" have their own unique charm. They are very different in feeling to the grand New York City compositions in that they are for the most part direct transcriptions of what he saw rather than what he could imagine. Apparently, he used these periods to sharpen his painting technique, and clearly, as the summer trips unfolded, he became more adept with brush and color. By 1916, his last summer in Maine, Bellows' palette had become chromatic, and he could use effectively every hue in the rainbow, as is evident in his **Ox Team, Matinicus, Maine** (Metropolitan Museum of Art, New York, NY) and **Romance of Autumn** (Farnsworth Art Museum, Rockland, ME).

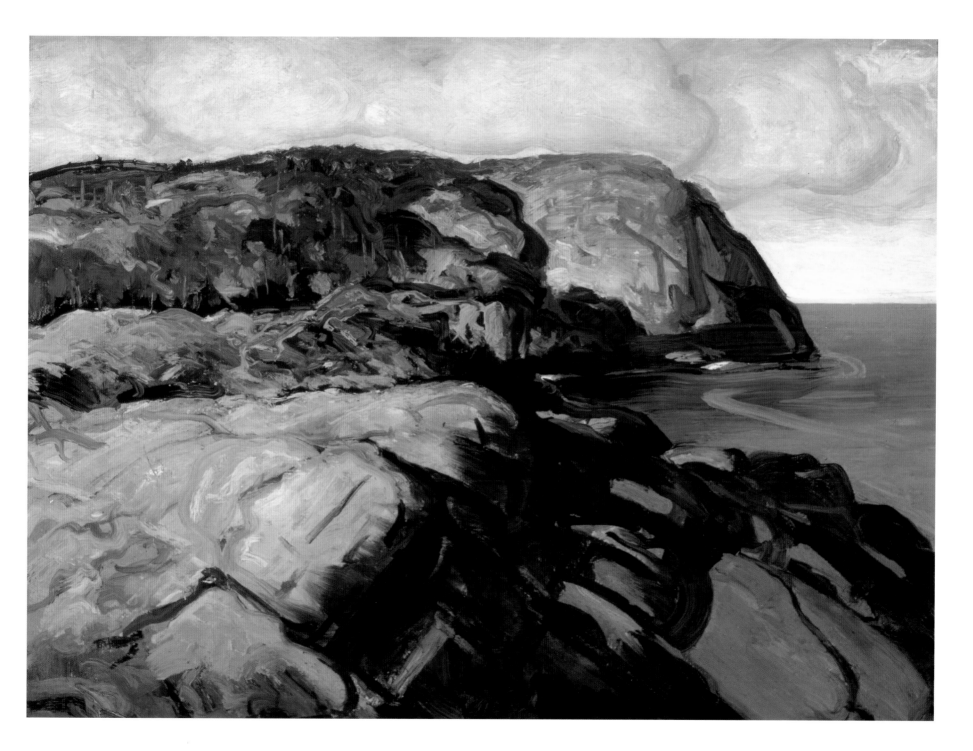

Bellows final years before his premature death were spent pursuing much of the same enjoyment in depicting nature that he had found in Maine. Two summers in Rhode Island were followed by five extended stays in Woodstock, New York. He appeared to get a great deal of satisfaction in the purity of painting. Occasionally, he would create some narrative epic, such as **Dempsey and Firpo** (Whitney Museum of American Art, New York, NY), but for the most part his landscapes remained true to what was observed, not what could be rearranged. He saved much of his interpretive skills for portraiture, a subject matter that always piqued his curiosity. With Bellows dying so young, we will never really know for sure where he was headed in the next decade of his work. He seemed though, to be always looking for something new to tackle, a new insight, a new way of understanding the world that surrounded him. My old friend decided long ago that Bellows had an imaginative mind and a unique vision, and so early on he chose one of the small Monhegan paintings of waves crashing on the rocks to add to his collection. We have talked about this painting many times, and we both agree that rarely do any of the other artists that he owns reach the level of perfection of Bellows. My friend will keep looking for another gem, flawed yet thrilling in its parts, while we should take the opportunity of this exhibition to see the mastery that Bellows so easily generated and invites us to see.

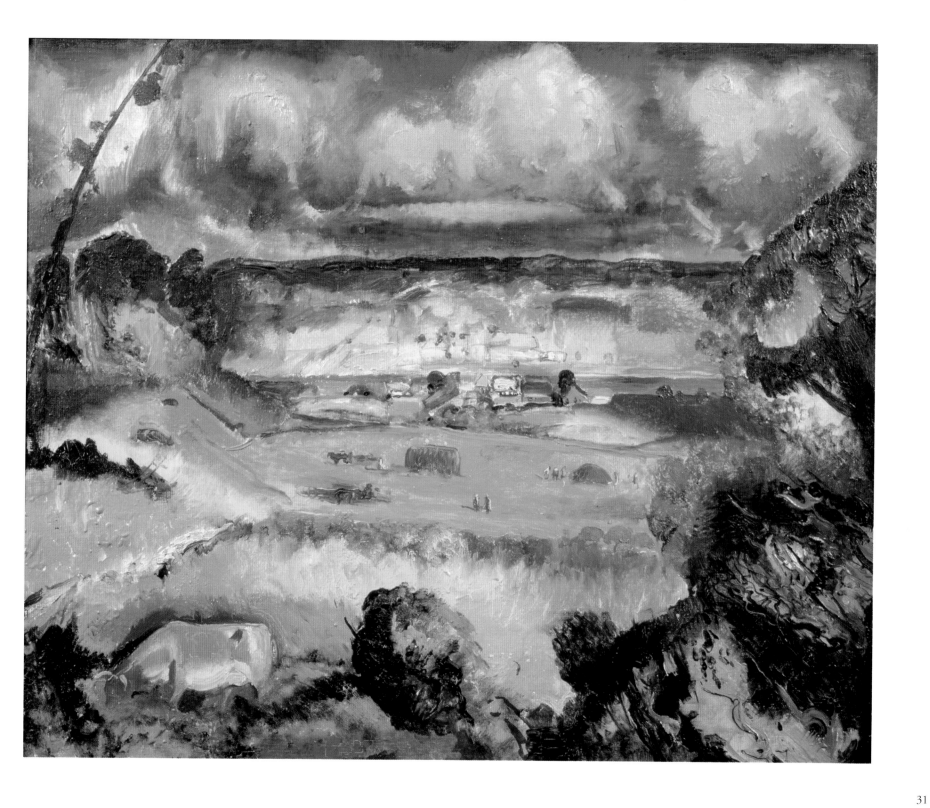

Evening Group, 1914
Oil on composition board
25 × 30 inches
Memorial Art Gallery of the University of Rochester
Marion Stratton Gould Fund
Photo by James Via
(not in the exhibition)

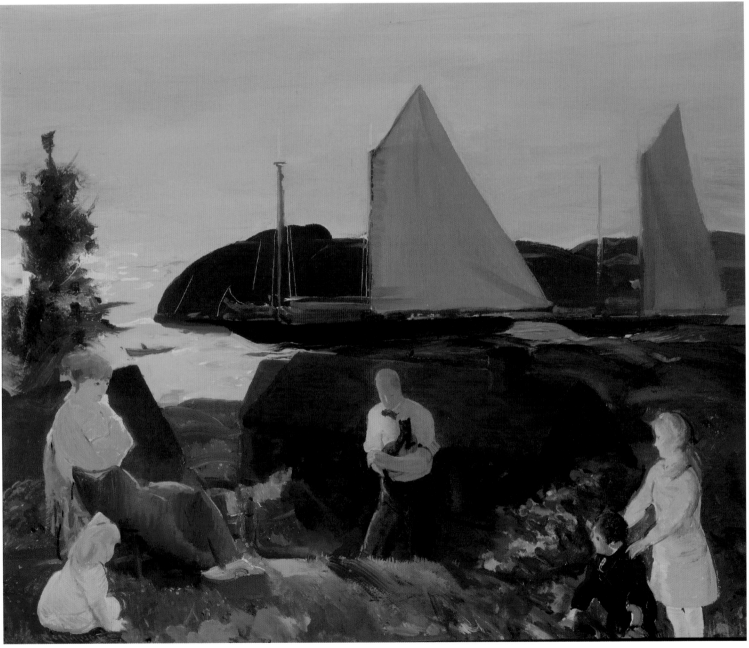

New Ideas and Impressions:
Bellows's Letters and the Search for the Perfect Place

MARJORIE B. SEARL

Bellows's images—created with pencil, ink, paint and words—record the artist's impressions of his world. Exhibitions of his paintings point to his undisputed stature as one of the nation's greatest artists, remembered particularly for his cityscapes. His prints, credited with initiating the revival of twentieth-century lithography, remain sought after. And, as visitors to *The Powerful Hand of George Bellows* quickly discover, his drawings engage the mind as well as the eye, whether they were created as illustrations for books or journals, preparatory versions of subsequent works, or quick sketches in the moment. While Bellows's legacy of paintings and works on paper has been in the public eye for over a century, less known is the George Bellows who drew powerfully in words as well as images. Although not a diarist, he was an indefatigable and unselfconscious letter writer, leaving a record that flows alongside his artistic output. From humorous accounts of mishaps and mentions of illnesses and injuries to reflections on aesthetics and technical challenges, Bellows's correspondence is an engaging narrative about his world and, by extension, his art.

While the many publications that have chronicled Bellows's art and life describe how he was seen and understood by others, Bellows's letters bring us closer to how he saw himself. His fresh style, his commentary about his own work, and his ability to laugh at himself and invite others to laugh with him are qualities that are worth more than the words of any academic writer at a generational remove.

To the twenty-first-century eye, Bellows's letters read rather like a quest narrative, particularly those relating to his summer travel and reactions to his surroundings. His periodic shifting of locales may have been the result of restlessness or of circumstances (a commission brought him to California, for example), but the fact that he made the decision to purchase land in Woodstock and that he built his own house there suggests that, after almost ten years of searching, one part of the journey was over and a new one about to begin.

Of course it is dangerous to project grand explanations about an artist from what is, by necessity, an incomplete record. On the other hand, the coexistence of such a large, well-documented body of work with a substantial, personal collection of letters does provide a narrative framework for some fairly solid assumptions about George Bellows.

Imagine a graph mapping the first three decades of the twentieth century, upon which are tracked the dates of Bellows's city paintings, his travels beyond Manhattan and New Jersey, the births and early years of his two daughters, and local and international events. Such a visual aid would suggest that by 1914, Bellows was, in fact, ceasing to "see" the city as subject, as Glenn Peck corroborates in his essay in this catalogue.

We can't know for sure why Bellows began turning away from the city, but it is not hard to speculate that both he and the environment that inspired his early work had changed in ways that sent him off in search of new sources of inspiration. Perhaps Bellows's love affair with New York City had become tarnished by the encroaching realities of urban life—crowds of immigrants, dirt from pollutants, noise from increasing numbers of automobiles, the pervasive film left behind, even in Bellows's exclusive Gramercy Park neighborhood, by coal-burning furnaces, trains, and boats. By 1914, he had become a family man with two young daughters. The New York art world was still reeling from the impact of the Armory Show. And in June, the world itself was rocked by the onset of World War I, surely the most sobering political event in Bellows's adult life.

Meanwhile, there seemed to be a general trend away from urban subject matter after 1914. While *Cliff Dwellers* was a third-prize winner in Pittsburgh that year, the opening of the Spring National Academy exhibition featured subjects such as Gloucester harbor, an odalisque, and sunny landscapes—including Bellows's bucolic *A Day in June*, a brilliantly lit park scene with a bare nod to its urban setting, the antithesis (or perhaps the pendant to) *Cliff Dwellers*.[i]

So, if not the city as subject, then what? Emma Bellows attributed her husband's summer wanderings to a desire to escape the heat.[ii] Glenn Peck, in his accompanying essay *Bellows and the Creative Concept*, describes the artist's working vacations, which were spent primarily in Maine and the Catskills with some intermittent forays to other venues, and nearly always in the company of friends and family. But the urge to travel may have run deeper. Bellows's summer letters to Emma and to his friend and mentor, Robert Henri—beginning in Moneghan, an island off the coast of Maine in 1911 and closing in Woodstock, New York in 1924—reveal insights and internal conflicts about his life and work that continuously motivated him to seek new views, viewpoints, and inspiration.

Bellows's scrawl is distinctive and sprawling, like nearly everything else about him, and his own particular brand of punctuation (separating phrases with 'x's) and interspersed diagrams and sketches (a circle with vibrating lines radiating from it standing for "concentrated kisses" in a letter to Emma) give the letters nearly as strong a visual impact as his drawings.[iii] The content ranges from passionate to entertaining to philosophical; it is tangy, energetic, often critical, and unusually expansive in his expressions of love for his work, his family, and his friends. A typically "Bellows" description of fellow painter Randall Davey ("Dave," "Randall the Short") in Monhegan is a good example:

Dave you must know has no small nature although he is exceeding short in the legs. His arms and feet are full to the brim and his garments except trousers will do.[iv] (August 9, 1911)

To his wife, Emma, he wrote from a hospital bed in San Francisco, where he awaited surgery to remove his tonsils:

You are the most loved girl that ever was and there are many reasons besides my personal whim, prejudice and natural imagination. I am one of the world's great girl pickers and as such hope to go down in history. Me to you, Geo.[v] (August 22, 1917)

To Robert Henri, technical breakthroughs are often interspersed with good-natured banter:

Another good discovery I am just working on is what color to keep under water and what to keep out....The colors dry outside rather fast and do not change very much in water for a week or so. I have therefore divided my palette which contains all colors through seven octaves up to white down to black…and it is much better…[F]ollowing out the principles of Marratta, Abenscher and Ross I have actually surprised myself with the results. It may sound like a little extravagance of boasting but I seem to have happened most naturally on certain results similar in different instances to a number of the old masters. I have a strange tendency to think of certain of them in certain pictures. One of them is my Goya. One my Hals. One my Velasquez. Two Holbeins. A Titian and a Michael Angelo [sic]. One Holbein has a cross of Cézanne. The other a touch of Veronezze [sic]. The bad ones are just plain Bellowzes.[vi] (Monhegan, August 21, 1914)

As for his travels, a discussion thread may be picked up that begins in Monhegan and ends in Woodstock—Bellows's critique of locales to which he has ventured in the hope of finding inspiration.

Moneghan, in 1911, prompted Bellows to write to Emma:

This is the most wonderful country ever modeled by the hand of the master architect.[vii] (August 9, 1911)

But Moneghan, though filled with inspiring subjects like that of the Columbus Museum of Art's *An Island in the Sea* (1911), was a difficult island to reach with two young children. By 1916, Camden, Maine became the Bellows family destination—slightly farther up the coast, but on the mainland. He wrote Robert Henri in New Mexico:

[T]he "mountains" are fine as being a lowlander I have never seen any real hills and I have "introduced them as a motif" into several works of art…in all probability my own output will be few but large. I brought with me this summer those temptations of the young, a number of big fellows meaning canvases and it takes me more time and I feel very important in caressing their surfaces. This situation is probably a good condition as inspiration is not as rampant around here as it is at Monhegan for instance. But like Glackens of Belleport [*sic*] I have children.…[viii] (August 10, 1916)

An Island in the Sea, 1911
Oil on canvas
34.25 × 44.125 inches
Columbus Museum of Art, Ohio
Gift of Howard B. Monett 1952.025

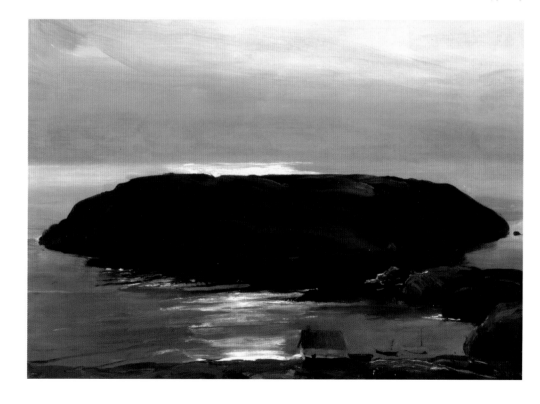

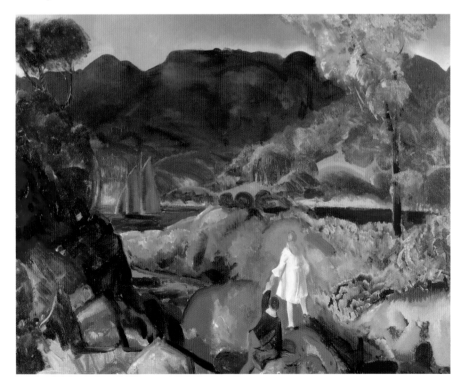

Two months later he wrote to Henri again:

Just returned from Matinicus where I had a great time and did extra fine work. I am not trying to complete everything here but rather searching for new ideas and impressions and trying to learn as much as possible.[ix] (October 5, 1916)

Maine inspired him to paint the brilliant *Romance of Autumn* (1916, Farnsworth Museum), but the next summer, Carmel, an exceptionally picturesque locale on the California coast, elicited a rather ho-hum response from Bellows, who had been warned by Henri that it would be no different than being "back East." In an August letter, he acknowledged that Henri was right:

This place is exactly like Maine. Fog and all. Only the headlands, trees, even the sea look as if they had just come out of the shop. I haven't been excited once but painted good portraits of Anne and Jean, notably the latter....I have been all over the county without finding anything very startling but lots which in the right mood would do the trick.[x] (August 7, 1917)

And furthermore, this country would be wonderful to live in for anybody but a landscape painter. There are lots of wonderful models in Monterey and a few here but this is an "artists colony" and wonderfully ugly. Looks like a Methodist camp meeting grounds (in spots)….there are fine hills and country but too darn placid.[xi]

He is even less inclined to return to New York City, and asks Henri in that same August 7 letter about how to "bamboozle the [Art Students] League to let me stay away a while in October…excusing myself for a month from the important work of making young artists for the important work of making young pictures." In other words, he hopes to convince the League to hire John Sloan in his place: "I could do better now if I felt I didn't have to go back Oct 1st….I want to spend some time with you [in Santa Fe] if you still like me and I don't want to go back a little bit."[xii]

It is telling that Bellows, whose success was built on his highly charged city scenes and fight scenes, was in 1917 calling himself a landscape painter. Bellows writes persuasively to Emma in Carmel from his hospital room on August 22 while he awaits a tonsillectomy: "I think for my work its best for me to see Santa Fe anyway and work there." He leaves the planning decisions to her, as "you are more able to judge of these things as I'm too interested in getting inspired….don't try to save money but lets have a great summer and get a lot of great work done…." [xiii]

Summering in Newport, Rhode Island in 1918–19, Bellows painted subjects inspired locally (e.g., tennis matches and rural landscapes like the Columbus Museum of Art's *Boy and Calf, Coming Storm*) and by events of the recent world war (*Edith Cavell* 1918, Museum of Fine Arts, Springfield, Mass.), *Massacre at Dinant* (1918, Greenville County Museum of Art, South Carolina). These were heroic subjects—even, as one writer put it, operatic.[xiv] In the span of six or seven years, Bellows had established a rhythm of painting in the summers and teaching and producing prints and drawings in the winter. Nonetheless, the fragmentation of his life and the rather restless diversity of subject matter was taking its toll. Emma Bellows recollected:

After summers on Long Island, Monhegan Island, Ogunquit, Camden and Matinicus Island—Maine, Middletown, Rhode Island, Carmel, California, and Santa Fe, New Mexico, George Bellows began considering Woodstock, New York as a solution to the ever-recurring problem—where to spend the summer? Because hot weather had a very enervating effect upon him he was not sure Woodstock would be cool enough for hard work but after consulting his friend Gene Speicher [painter Eugene Speicher] decided the only way to find out was to rent a house for the season and await results. Fortunately the original Shotwell house was available so 1920 found the Bellows family—including Grandma Bellows and her sister Fanny from California—very comfortably settled for their first summer in Woodstock and the best summer studio George Bellows ever had. Everything worked out perfectly painting was never better and everyone was happy. (Close harmony and barbershop chords filled the summer nights.)[xv]

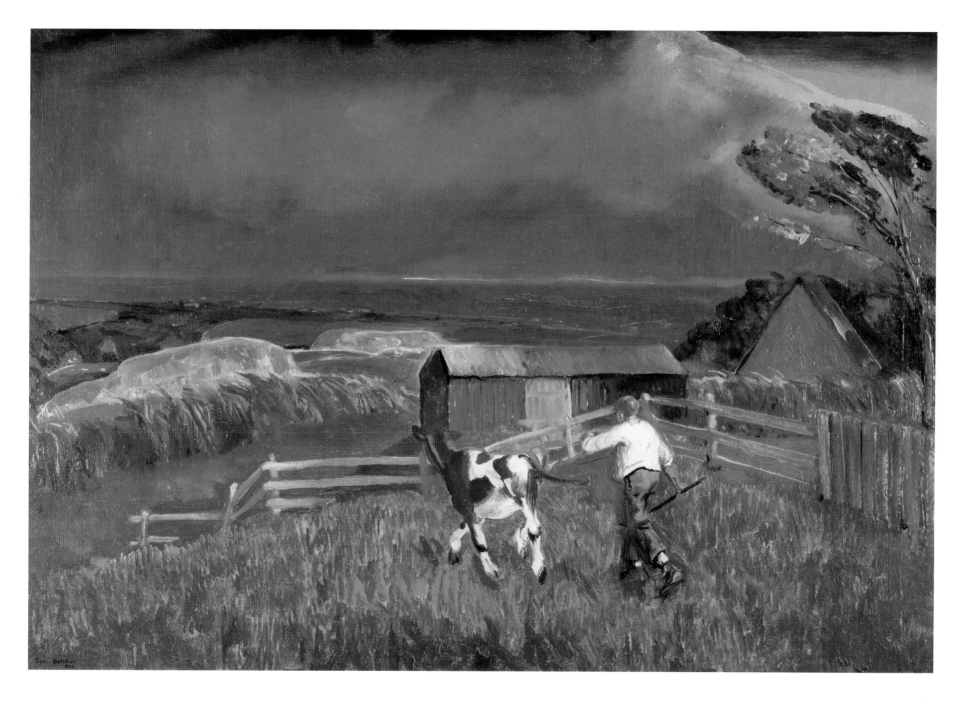

Emma's remembrances may have been selective; elsewhere, she mentions her concerns about her husband during the spring of 1920 and an April visit to the Speichers in Woodstock that suggested to her that his low spirits might be cured by a return visit. According to Bellows biographer Charles Morgan:

March found him working and reworking the tennis theme, but new ideas eluded him. He felt cramped and unable to settle down seriously to anything. When the Speichers asked George and Emma to visit them in their comfortable new house in Woodstock at the foot of Mount Overlook, they accepted with alacrity.[xvi]

Bellows himself comments to Henri in September that he came to "these mountains in quest of vigor and health."[xvii]

To his aunt, an optimistic Bellows wrote in May 1920:

We are going to a beautiful outdoor mountain country, famous among artists and where I have procured a wonderfully fine estate, a very large house in the center of a farm on the slope of the second highest mountain in the Catskills.[xviii]

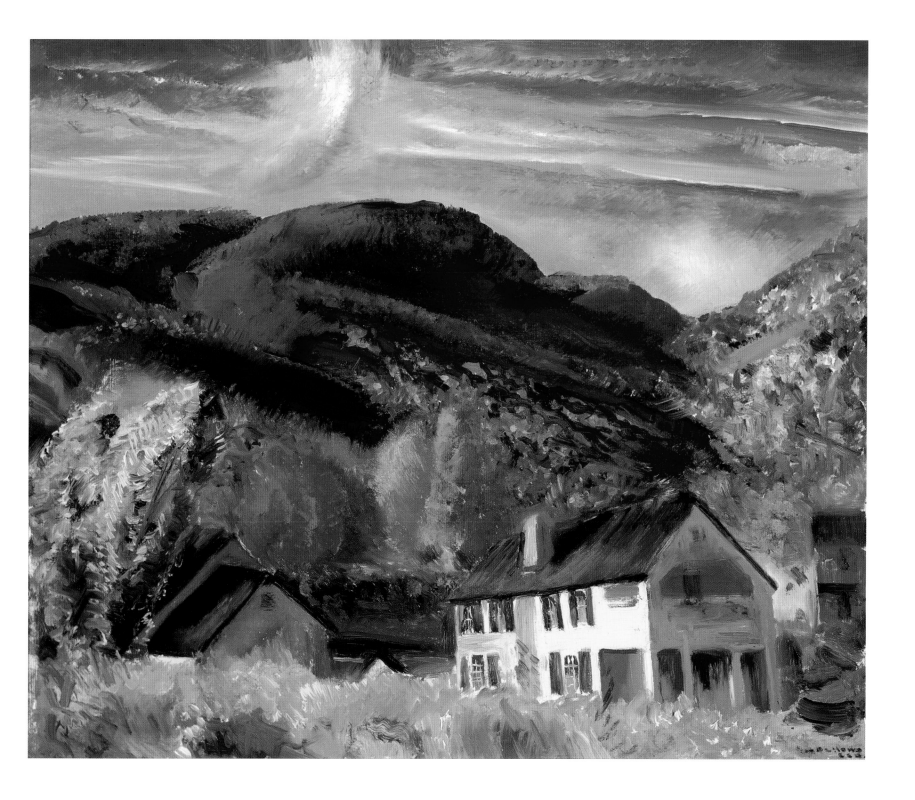

43

And by June, a satisfied Bellows wrote to Henri:

[W]e are finely pleased with what we have here. This is the first time in the summer that I have had a real studio, and I am putting it to work with a vengeance. I have under way a number of promising works mostly big fellows, and all going well. Have been playing tennis with Jean [Eugene Speicher] and Emma and have with Emma made a big vegetable garden and also screened in a sleeping porch and an evening sitting porch. So my health is abnormal.[xix]

And by the end of July 1922, Bellows can claim yet another accomplishment: building his own home and studio, which he painted in October, 1924—The Mennello Collection *My House, Woodstock*.

The house, studio, grounds, swimming pool are all a great success, and I exhibit them like a fine picture.[xx]

While he remained in Woodstock through the autumn, New York still persisted in claiming some of his time. And even in Woodstock, he writes in November, "I am considerably depressed by the number and size of the burdens wished on me by fate just at present. They all have to do with other people's interest and not my own....As soon as possible I am going to resign all offices in everything and let my temper have a chance." The "burdens" mostly had to do with group exhibitions and a conflict with Hearst about drawings for an H. G. Wells story. But that is all tempered by the opportunities to paint: "Gene and I and Charlie [Rosen] have been going out every day at 8:30 and coming home at dark with landscapes."[xxi] Even so,

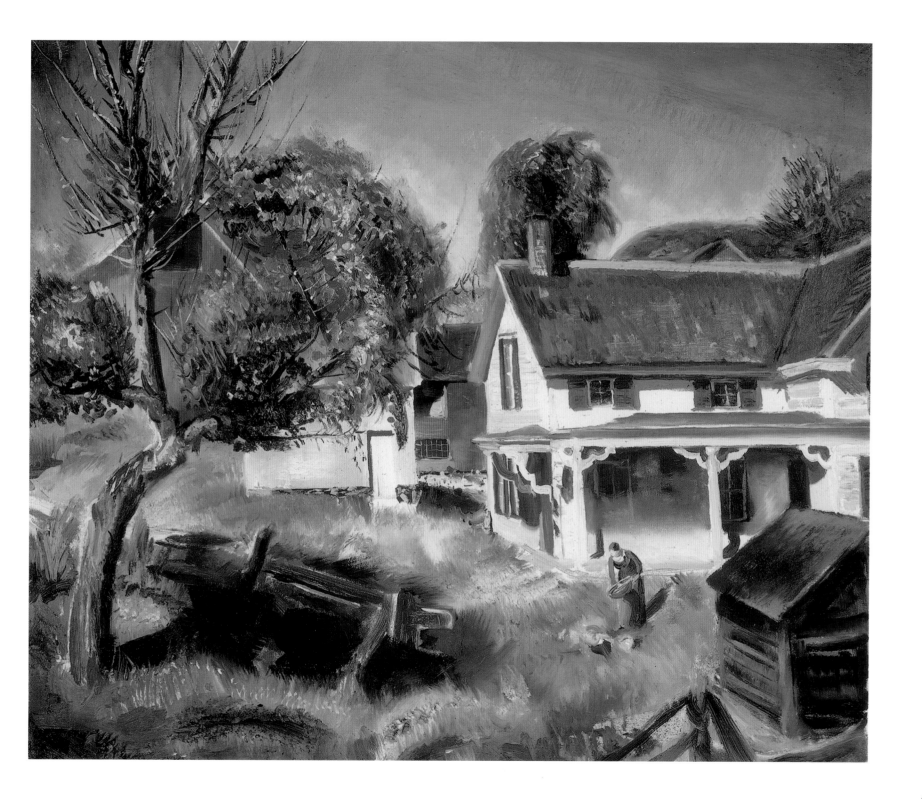

I have had a curious siege of cromos buckeyes and rotters. Smug bad work. They look good outdoors and like hell when they come in. There are a few which escaped the blemish. We have had a great time, and great weather….all my work this summer or rather this fall seems quite different. It may be good and it may be rot, darned if I know. I just paint and this is what happens.[xxii] (November 3, 1922)

And as he prepares to return just before Thanksgiving he writes Henri:

I have had a delightful time at least fixing up the place in the country. The more we do the better it gets. Everything has been done well and the all is a great success. I want to bring you up here in the early spring to paint if you will come.[xxiii]

Nearly a year later, in 1923, the message he sends to the newly married Leon Kroll indicates that inspiration in Woodstock has not let up: "I find that I have had a very successful summer, with a few, for me very good pictures" (*Emma, Anne and Jean* and *The Crucifixion*). This is followed by a letter to Henri in early 1924 describing his public success after "a great summer."[xxiv] And, indeed, in 1924, three of his paintings were exhibited in Paris.[xxv]

We will never know if Woodstock would have continued to inspire the restless Bellows, as he died suddenly in January 1925. However, in the immediate postwar world, the pastoral freshness of Woodstock was a godsend. His home on a quiet lane was flanked by a gentle stream on one side and his sunlit studio on the other, and the quiet was disturbed only by the sounds of children playing (and even they were enjoined from

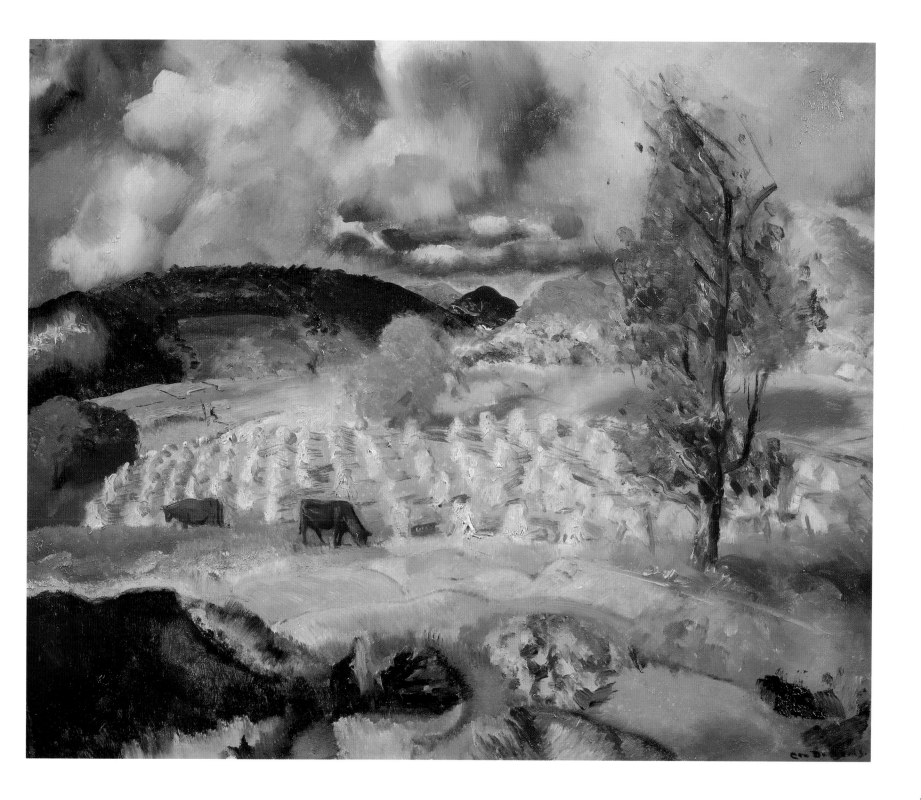

disturbing their father's concentration: "The only thing wrong is too much noise, and I have to carry this with me now wherever I go. I encourage out of door far away exercise for children, with all my energy"[xxvi]). While Cooper Lake was not the ocean, the majesty of the Catskill Mountains and the great cosmic dome of the ever-changing sky provided the natural grandeur and strength of subject that Bellows had identified in Monhegan views, in the human form, and in the urban dimension. In one locale, surrounded by family, like-minded friends and fellow artists, and beauty everywhere he turned, Bellows was able to integrate the ingredients with which he could express his soul's delight in paint, free from the turmoil that he experienced in New York: "I am playing tennis twice a week, doing carpenter work and gardening and trying to store up condition enough to stand the National Arts Club poison gas for another season….Am looking forward to not coming home to teach, to staying here till snow flies."[xxvii]

In the few short years during which he claimed the village as his home, Bellows was clearly preparing to tackle new themes and subjects, even though he remained a landscape painter inspired by Woodstock scenery: *Jim Twadell's Place* (1924, Harn Museum of Art, University of Florida); *Cornfield and Harvest* (1921, Columbus Museum of Art); *White Fence* (1920, Hunter Museum of American Art), among others. The masterpieces of those years—among them *The Crucifixion* (1923, Lutheran Brotherhood, St. Paul, Minn.); *Two Women* (1924, private collection), *Lady Jean* (1924, Yale University Art Gallery); *The White Horse* (1922, Worcester Art Museum)—seemed to signal a new relationship between Bellows and worlds seen and unseen, a new awareness of his place as an interpreter of the human condition within the universe—a new identity for George Bellows as an Old Master in a Woodstock studio.

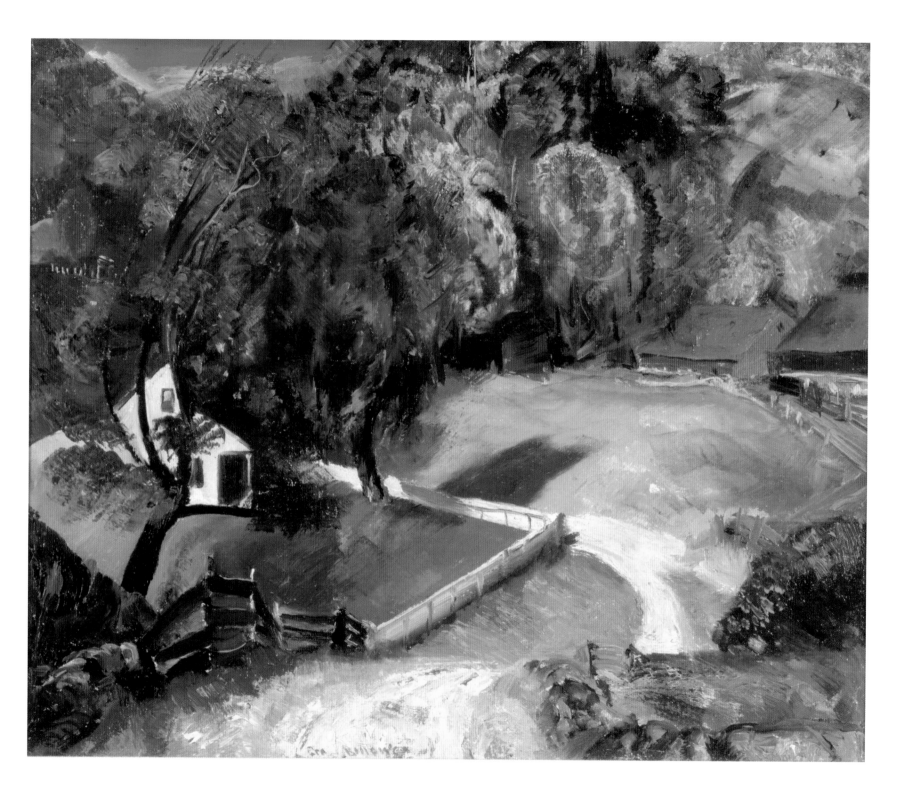

Footnotes:

i "Spring Academy Open," *New York Times*, March 21, 1914, p. 12.

ii Emma Bellows manuscript, in George Wesley Bellows Papers, Box 4, Folder 7, Amherst College Archive and Special Collections, Amherst College Library.

iii George Bellows to Emma Bellows, August 9, 1911, in George Wesley Bellows Papers, Box 1, Folder 3.

iv Ibid.

v George Bellows, to Emma Bellows, August 22, 1917, in George Wesley Bellows Papers, Box 1, Folder 5.

vi George Bellows to Robert Henri, August 21, 1914, in Robert Henri Papers, Box 1, Folder 18, Yale Collection of American Literature, Beinecke Rare Book and Manuscript Library, Yale University.

vii George Bellows to Emma Bellows, August 9, 1911, in George Wesley Bellows Papers, Box 1, Folder 3.

viii George Bellows to Robert Henri, August 10, 1916, in Robert Henri Papers, Box 1, Folder 19.

ix George Bellows to Robert Henri, October 5, 1916, in Robert Henri Papers, Box 1, Folder 20.

x George Bellows to Robert Henri, August 7, 1917, in Robert Henri Papers, Box 1, Folder 22.

xi Ibid.

xii Ibid.

xiii George Bellows to Emma Bellows, August 22, 1917, in George Wesley Bellows Papers, Box 1, Folder 5.

xiv Charlene Engel, "The Man in the Middle," *American Art* 18 (2004): 85.

xv Emma Bellows Manuscript, in George Wesley Bellows Papers, Box 4 Folder 7.

xvi Charles Morgan, *George Bellows: Painter of America* (New York: Reynals & Co., 1965), 235. Thanks to Ronald Netsky for locating this reference.

xvii George Bellows to Robert Henri, September 21, 1920, in Robert Henri Papers, Box 2, Folder 27.

xviii George Bellows to Fanny Daggett, May 14, 1920, in George Wesley Bellows Papers, Box 1, Folder 7.

xix George Bellows to Robert Henri, June 27, 1920, in Robert Henri Papers, Box 2, Folder 27.

xx George Bellows to Robert Henri, July 25, 1922, in Robert Henri Papers, Box 2, Folder 29.

xxi George Bellows to Robert Henri, November 3, 1922, in Robert Henri Papers, Box 2, Folder 29.

xxii Ibid.

xxiii George Bellows to Robert Henri, undated [November 1922], in Robert Henri Papers, Box 2, Folder 29.

xxiv George Bellows to Robert Henri, January 8, 1924, in Robert Henri Papers, Box 2, Folder 31.

xxv 1924 Exhibitions, in Charles H. Morgan Papers on George W. Bellows, Box 5, Folder 14, Amherst College Archives and Special Collections, Amherst College Library.

xxvi George Bellows to Robert Henri, August 10, 1920, in Robert Henri Papers, Box 2, Folder 27.

xxvii Ibid.

The Old Farmyard, Toodleums, August 1922
Oil on canvas
35.5 × 57.5 inches
On loan from the Bank of America Collection, Charlotte, North Carolina
Photo by Randall Smith

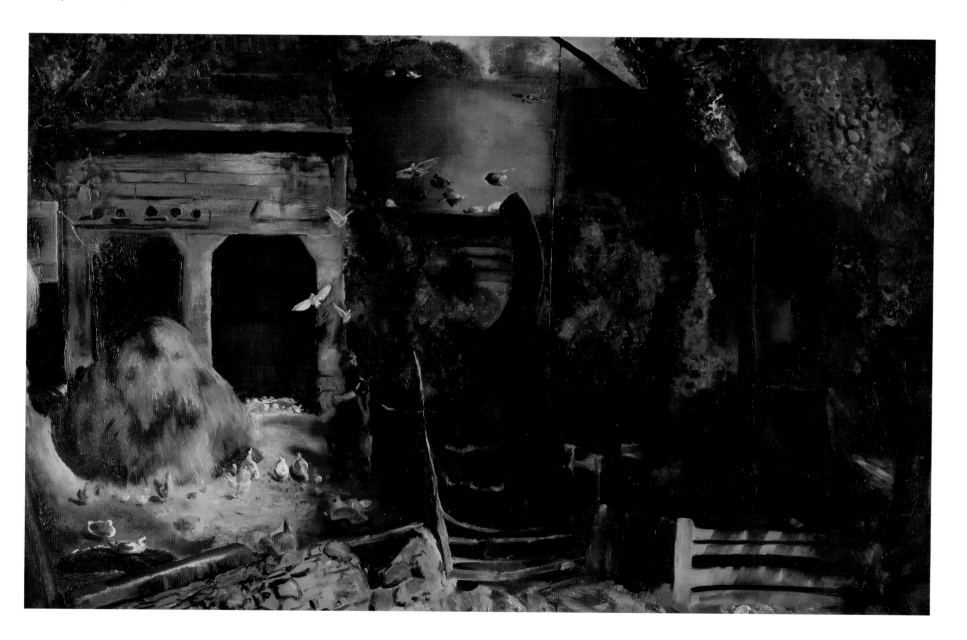

Barnyard and Chickens
Oil on canvas
17.5 × 21.5 inches
On loan from the Bank of America Collection, Charlotte, North Carolina
Photo by Randall Smith

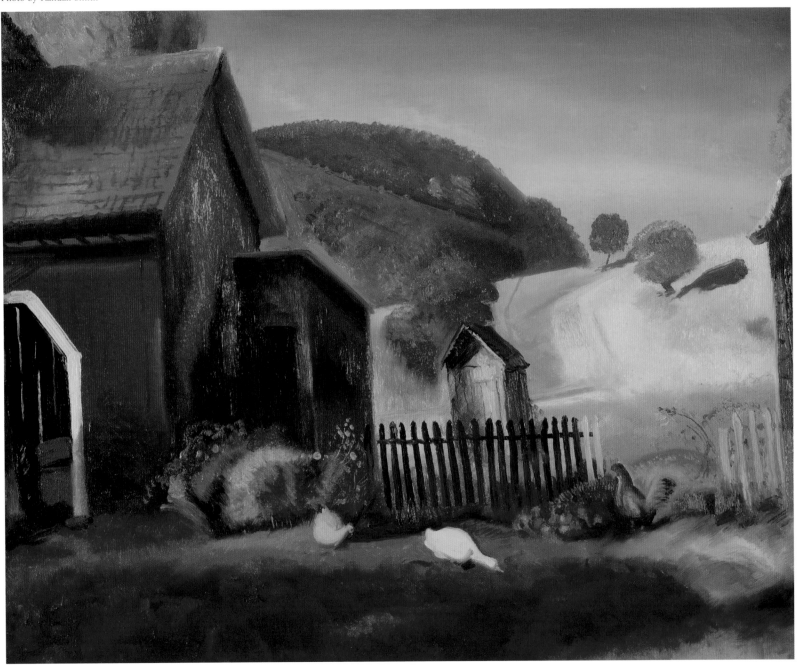

Hudson at Saugerties, November 1920
Oil on canvas
16 × 23.562 inches
Columbus Museum of Art, Ohio: Museum Purchase Howald Fund 1947.095

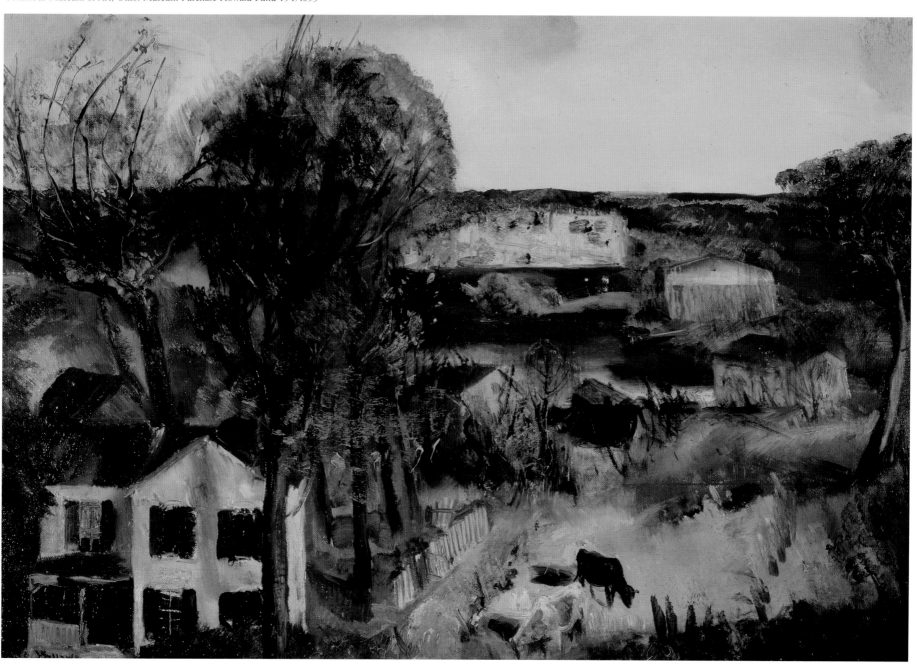

Autumn Brook, October 1922
Oil on panel
16.5 × 24 inches
Memorial Art Gallery of the University of Rochester
Bequest of Muriel Englander Klepper and Marion Stratton Gould Fund. Photo by James Via. (not in the exhibition)

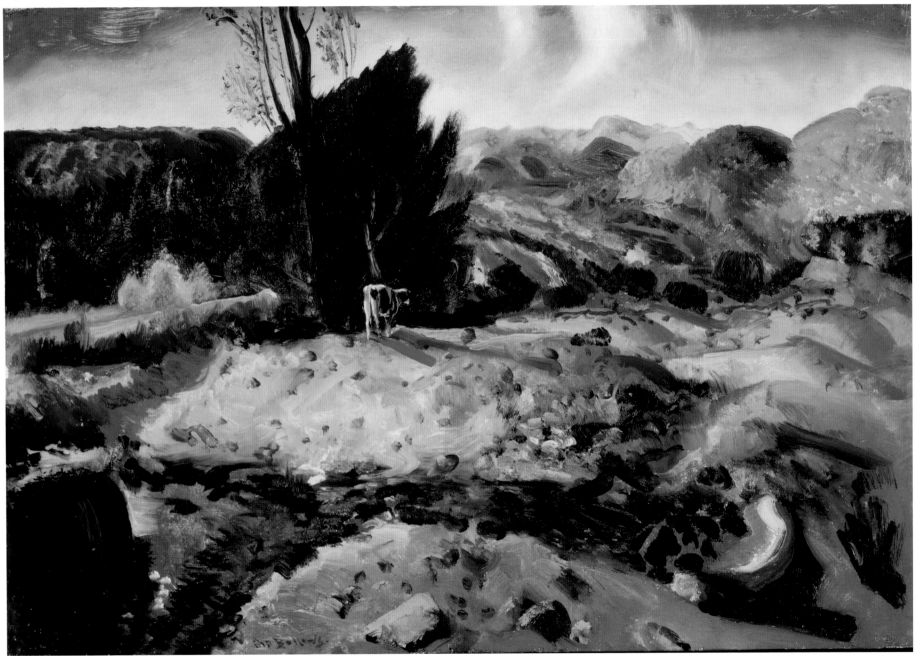

Journey of Youth

BERRY-HILL GALLERIES, INC.

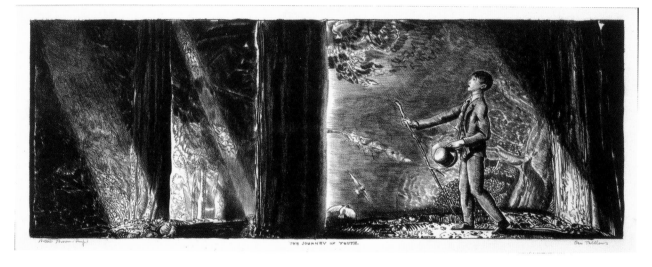

The Journey of Youth, 1923-24
Lithograph on paper
15.5 × 26.75 inches
On loan from Berry-Hill Galleries, Inc., New York

In early 1922, Bellows was commissioned to create sixteen drawings for the Irish writer Don Byrne's novel *The Wind Bloweth*. The book was serialized in the *Century* magazine from April to September of that year, and published in book form in late 1922 by the Century Company. Both the oil and lithograph of *The Journey of Youth* relate to an illustrated drawing that appears on page 807 of the April 1922 issue of the *Century*. The oil ranks as one of Bellow's most colorful paintings. In this work Bellows sought to reveal color's expressive potential. In emulation of the intense juxtaposed colors he had seen in the paintings of such artists as Matisse and Gauguin he incorporates interesting combinations such as greens and purples. Bellows admitted that what he adopted above all from the "modernist movement" was "fresh, spontaneous pure color" (quoted in Charles H. Morgan, *George Bellows Painter of America*, New York: Reynal and Company, 1965, p. 135).

Byrne's novel tells the story of a Scotch-Irish boy's search for adventure and beauty. The search leads him to encounter strange places and people. Lauris Mason has related that Byrne's novel "reads

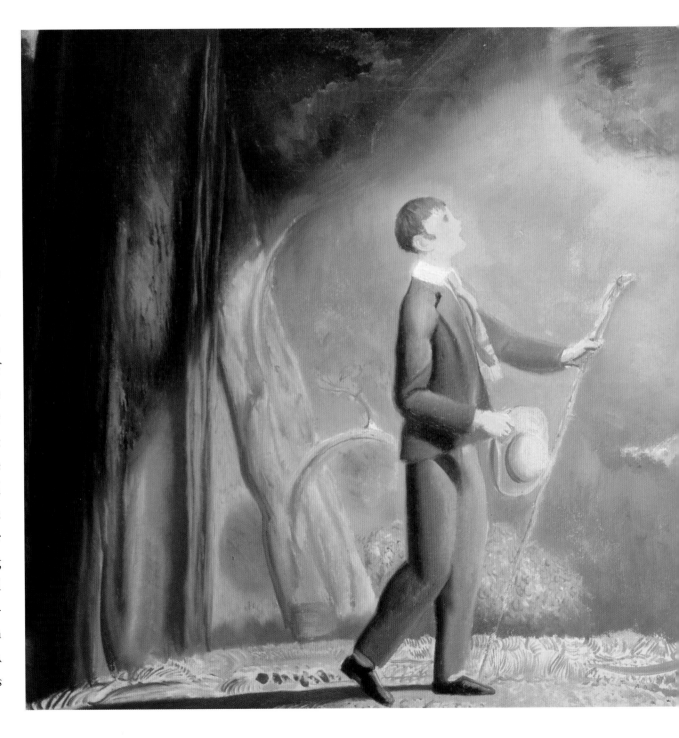

The Journey of Youth, 1922
Oil on canvas
27.5 × 59.5 inches
On loan from Berry-Hill Galleries, Inc., New York

like prose poetry; it is elusive, mystical, and dream-like, similar to ancient Irish legends" (*The Lithographs of George Bellows: A Catalogue Raissonné* [San Francisco: Alan Wofsy Fine Arts, 1992], p. 219). The image depicted in *The Journey of Youth* relates to the following text in *The Wind Bloweth*: "Because it was his fourteenth birthday they had allowed him a day off from school . . . and because there was none else for him to play with at hurling or football . . . he had gone up the big glen. It was a very adventurous thing to go to the glen . . . He left the main road and turned . . . and here the moss was yellowish-green and there red as blood . . . In the summer the sun would shine through the clearing of the trees, and there was always a bird singing somewhere near. But it was a lonely place . . . at all times and season, and in the moonlight and in the sunlight . . . A very silent place a mountain was" (Byrne is cited in Mason, p. 220).

Massacre at Dinant, 1918
Oil on canvas
49.5 × 83 inches
Collection of the Greenville County Museum of Art
Gift of Minor M. Shaw, Buck A, Mickel,
and Charles C. Mickel;
and Arthur and Holly Magill Purchase Fund
(not in the exhibition)

Exhibition Checklist

Gorge and Sea, 1911
Oil on canvas
34 × 26 inches
Mint Museum of Art
Charlotte, North Carolina
Gift of the Mint Museum Auxiliary. 1983.35

Over to Blackhead, 1913
Oil on paperboard
27.25 × 34.875 inches
Telfair Museum of Art, Savannah, Georgia
Museum Purchase, 1936

Hudson at Saugerties, November 1920
Oil on canvas
16 × 23.562 inches
Columbus Museum of Art, Ohio: Museum Purchase
Howald Fund 1947.095

Cornfield and Harvest, October 1921
Oil on masonite
17.687 × 21.625 inches
Columbus Museum of Art, Ohio
Museum purchase, Howald Fund 1947.096

Boy and Calf, Coming Storm, 1919
Oil on canvas
26.25 × 38.25
Columbus Museum of Art, Ohio
Gift of Mrs. and Mrs. Everett D. Reese 1976.045

Portrait of My Father, 1906
Oil on canvas
28.375 × 22 inches
Columbus Museum of Art, Ohio
Gift of Howard B. Monett 1952.048

An Island in the Sea, 1911
Oil on canvas
34.25 × 44.125 inches
Columbus Museum of Art, Ohio
Gift of Howard B. Monett 1952.025

Jim Twadell's Place, October 1924
Oil on canvas
20 × 24 inches
Samuel P. Harn Museum of Art, University of Florida
Gift of William H. and Eloise R. Chandler

The White Fence, October 1920
Oil on canvas
20 × 25 inches
Hunter Museum of American Art, Chatanooga,
Tennessee. Museum Purchase

Ox Team, Matinicus Island, Maine, 1916
Oil on plywood
22 × 28 inches
Lent by The Metropolitan Museum of Art, New York
Gift of Mr. and Mrs. Raymond J. Horowitz, 1974

My House, Woodstock, October 1924
Oil on panel
17 × 22 inches
Collection of Michael A. Mennello

Laura, 1925
Oil on panel
40 × 32 inches
Collection of Michael A. Mennello

The Rich Water, 1913
Oil on panel
15 × 19.5 inches
Collection of John & Dolores Beck

Lillian, 1916
Oil on board
38.375 × 30.375 inches
Collection of John and Dolores Beck

Romance of Autumn, 1916
Oil on canvas
32 × 40.125 inches
Farnsworth Art Museum
Gift of Mrs. and Mrs. Charles Shipman Payson, 1964

The Old Farmyard, Toodleums, August 1922
Oil on canvas
35.5 × 57.5 inches
On loan from the Bank of America Collection
Charlotte, North Carolina

Barnyard and Chickens
Oil on canvas
17.5 × 21.5 inches
On loan from the Bank of America Collection
Charlotte, North Carolina

Geraldine Lee #2, 1914
Oil on panel
38 × 30 inches
Collection of The Butler Institute of American Art,
Youngstown, Ohio. Museum Purchase 1941

The Journey of Youth, 1922
Oil on canvas
27.5 × 59.5 inches
On loan from Berry-Hill Galleries, Inc., New York

The Journey of Youth, 1923-24
Lithograph on paper
15.5 × 26.75 inches
On loan from Berry-Hill Galleries, Inc., New York

Clouds and Meadows, 1919
Oil on canvas
20 × 24 inches
On loan from Berry-Hill Galleries, Inc., New York

Acknowledgements

FRANK HOLT

There are several misconceptions held by the general public when they consider how any exhibition of visual art is organized and presented to the viewing audience. First, is the idea that most museums and collectors just sit around waiting for requests for loans of works of art from their collections. Actually, it requires many months, and sometimes years to secure the paintings or other works of art. Works may have already been promised to other exhibits, some may require conservation, and some simply cannot be loaned. The George W. Bellows exhibit has been in the planning stages since the spring of 2006. During that time period, many individuals have become involved and each one has made a contribution that has helped to insure the success of the exhibit.

My sincere appreciation is extended to Marjorie B. Searl, Chief Curator, Memorial Art Gallery of the University of Rochester for her wonderful insights to Bellow's personality. Through the inclusion of his personal notes and letters and those of his family and friends, she has provided with an intimate view of both his professional and personal outlook on life. Her essay "New Ideas and Impressions" explores the ideal of "place" in the paintings. She follows the artist as he makes his way from Monhegan Island, off the coast of Maine in 1911 to Woodstock, New York in 1924.

Through the years Margie has contributed many articles and essays that have added much valuable information to the field of Bellows scholarship.

Glenn Peck has elected to make major contributions in a similar, but different way. Through his research and working with the Bellows estate he has compiled the definitive "catalog raisonné" on the artist's paintings. The works have been located, photographed, fully documented and made available to the public on a website that is the definitive source for authenticity of the paintings. In his essay "Bellows and the Creative Concept" he provides the reader with an overview of the rich inventory of images created during a very productive, span of time. From the early fight scenes to the intimate and loving portraits of family and friends to the landscapes of the Maine coast, he traces the development of the artist.

To those museums and collectors who realized the importance of this exhibit to the community and to the museum, and who agreed to facilitate loans: Lillian Lambrechts, Senior Vice President, Director of Corporate Art Program, Bank of America, Mary Edith Alexander, Assistant Vice President, Art Program Manager/Curator, Bank of America, Charlotte, North Carolina; John and Dolores Beck, collectors, Winter Park, Florida; Frederick D. Hill, Director, Berry-Hill Galleries, Inc., New York; Louis A. Zona, Director, Rebecca Davis, Registrar, The Butler Institute of American Art, Youngstown, Ohio; Nannette V. Maciejunes, Executive Director, Melissa Wolfe, Associate Curator of American Art, Elizabeth Hopkin, Associate Registrar for the Permanent Collection, Jenny Wilkinson, Curatorial and Collections Assistant, Columbus Museum of Art, Columbus, Ohio; Laura S. Urbanelli, Director, Angela

Waldron, Registrar, Bethany Engstrom, Assistant Registrar, Farnsworth Art Museum, Rockland, Maine; Dr. Rebecca M. Nagy, Director, Laura K. Nemmers, Registrar, the Samuel P. Harn Museum of Art, University of Florida, Gainesville, Florida; Robert Kret, Director, Ellen Simak, Chief Curator, Elizabeth Le, Registrar, Hunter Museum of American Art, Chattanooga, Tennessee; Michael A. Mennello, museum founder/collector, Winter Park, Florida; Phil Kline, Executive Director, Jonathan Stuhlman, Curator of American Art, Martha Tonissen Mayberry, Registrar, Mint Museum of Art, Charlotte, North Carolina; Beth Moore, Assistant Curator, Courtney McGowan, Assistant Curator, Telfair Museum of Art, Savannah, Georgia; Philippe de Montebello, Director & C.E.O., Ida Balboul, Modern Art, Cynthia Chin, Assistant Registrar, Loans, Michelle Povilaitis, Registrar's Office, Deanna Cross, Rights & Reproductions, The Metropolitan Museum of Art, New York.

The second misconception that a lot of people have about organizing exhibits, is that one day you wake up and like Judy Garland and Mickey Rooney, decide to "put on a play". Most museums do not have Hollywood studios to make this happen, however, we can call on the many services in the community to help make it all possible.

To the entire crew at U.S. Art my appreciation for their patience and skill in helping with all of the arrangements for shipping and insurance. To their installation teams that took the time and effort to make the exhibit look professional. To the crews from the City of Orlando Facilities Management Bureau for making the museum look new and fresh (the visitor will not know, but we tried six different colors for two of the galleries before we "got it"). These guys continue to take a pride in the sense of ownership they show in maintaining the facility.

My appreciation to Kim Robinson, Office Manager, for assuming part of my administrative duties, to Will Adams, Museum Specialist, who was instrumental in the creation of the self-guided audio tour produced for the exhibit and to Nicole Parks, Museum Intern, for telling people that "he is not in the building" while I was working on the exhibit. To Bob Melanson for his help in editing the Curator's Statement and for the encouragement extended in making sure that the comments truly conveyed my thoughts. And last, Buz Pitts, for his seemingly tireless efforts in designing the printed materials and especially the catalog which will serve as the historical document for the exhibit.

— Frank Holt, *Executive Director*

Mennello Museum Boards